JULIUS SHULMAN'S LOS ANGELES

CHRISTOPHER JAMES ALEXANDER

THE GETTY RESEARCH INSTITUTE AND THE J. PAUL GETTY MUSEUM | LOS ANGELES

© 2011 J. Paul Getty Trust

**Published by the Getty Research Institute
and the J. Paul Getty Museum, Los Angeles**

Getty Publications
1200 Getty Center Drive, Suite 500
Los Angeles, California 90049-1682
www.gettypublications.org

Dinah Berland, *Editor*
Catherine Lorenz, *Designer*
Amita Molloy, *Production Coordinator*

Printed in Italy

Library of Congress Cataloging-in-Publication Data

Alexander, Christopher James.
 Julius Shulman's Los Angeles / Christopher James Alexander.
 p. cm.
 ISBN 978-1-60606-079-7 (pbk.)
1. Los Angeles (Calif.)—Buildings, structures, etc.—Pictorial works. 2. Architectural photography—California—
Los Angeles. 3. Shulman, Julius. 4. Architecture—California—Los Angeles—Pictorial works. I. Title.
 F869.L843A44 2011
 979.4'94—dc22
 2011016276

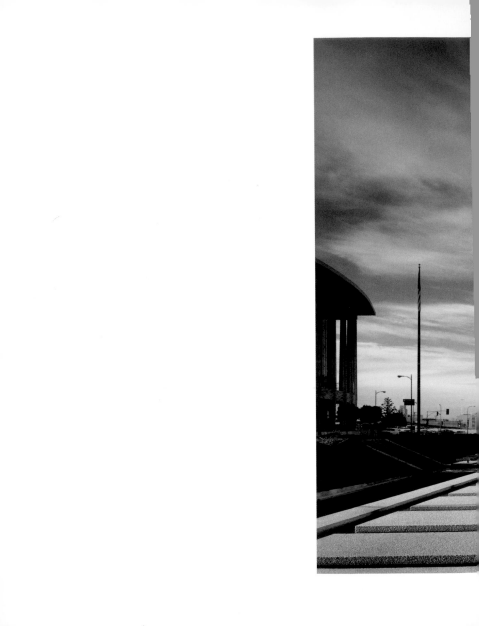

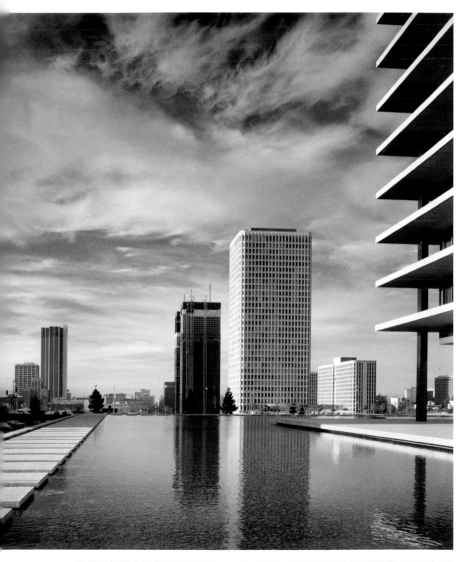

PLATE 1 | VIEW OF BUNKER HILL FROM THE DEPARTMENT OF WATER AND POWER BUILDING, 1971

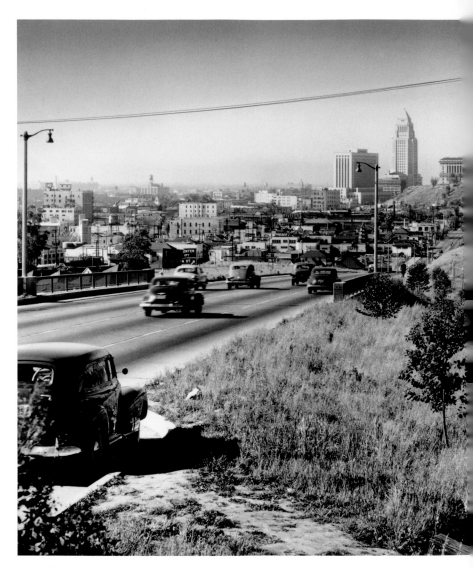

PLATE 2 | VIEW OF LOS ANGELES CITY HALL FROM THE PASADENA FREEWAY, 1949

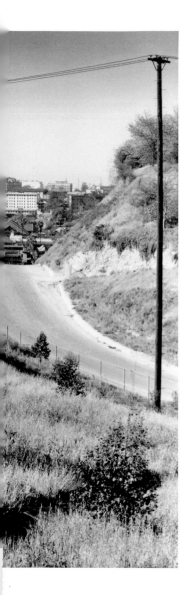

INTRODUCTION

Christopher James Alexander

Julius Shulman's calibrated union of innate vision, refined photographic techniques, and strategic business acumen enabled him to create among the most compelling images in architectural history. Whether documenting a skyscraper, a house, or a gas station, his compositional artistry and unerring precision present the structure in its most engaging, heroic light. Shulman's images transcend mere documentation of steel and glass, revealing the essence of an architect's vision and capturing the spirit of their time.

Born in Brooklyn, New York, on October 10, 1910, Shulman spent his early childhood on a Connecticut farm. At the age of ten he moved with his family to Los Angeles. From 1929 to 1936 Shulman audited courses at the University of California, Berkeley, then returned to Los Angeles. Soon after his arrival he experienced modern architecture for the first time, while visiting a house in the Hollywood Hills that Richard Neutra had designed for the journalist Josef Kun. An amateur photographer, Shulman sent Neutra six photos of the home as a gift. Impressed with the distinctive images, Neutra immediately hired Shulman to photograph additional projects, thereby launching an unanticipated, prolific career.

Shulman's long relationship with Los Angeles was a mutually dependent and beneficial affair. The city's pivotal role as the incubator of architectural exploration for design pioneers such as Richard Neutra, Charles and Ray Eames, Pierre Koenig, and John Lautner allowed Shulman to establish his reputation as the preeminent photographer of midcentury Modernism. In turn, Shulman's iconic images of the casual yet refined indoor/outdoor Southern California lifestyle, made possible by the region's mild climate, helped to define Los Angeles's mythic status as an alluring and dynamic city of the future.

International demand for his talent allowed Shulman to travel extensively; however, Los Angeles remained his home for nine decades. During his lifetime the city evolved into the second most populous metropolitan area in the United States and the sixteenth largest economy in the world. An efficient rail system, a sophisticated water-and-power infrastructure, the man-made Port of Los Angeles, the advent of the automobile, and surges in the oil, entertainment, aerospace, and biotechnology industries all fueled the region's

development and lured millions of new residents. Ambitious developers capitalized on this vibrant market and transformed L.A. into a sprawling conglomeration of diverse neighborhoods, outlying suburbs, and commercial centers linked by a network of broad boulevards and freeways. Shulman marveled at the region's expansion and reveled in the fact that he had, as he often stated, "grown with the city." This book includes rarely seen photographs that reveal the depth of Shulman's interest in Los Angeles's complex development.

Although Shulman is best known for photographs commissioned by masters of mid-twentieth-century residential architecture, as one of the most accomplished photographers in the business, he was sought out by a wide range of clients. His images for the Los Angeles Cultural Heritage Board (plates 5–8) elegantly depict the sophisticated, ornately detailed structures from the late 1800s and early 1900s that Los Angeles's founders built to emulate the strength and status of influential American cities to the east, such as Chicago and New York. In 1967 Shulman was hired by the Community Redevelopment Agency of Los Angeles to photograph the Bunker Hill Redevelopment Project Area, a vast urban renewal site. Shulman's passion for the city's growth made him the ideal photographer to craft a gripping visual narrative of the downtown renaissance, which was used to promote the area to international businesses and investors (e.g., see plates 1, 12, 13). In 1958, however, the Los Angeles architect Welton Becket had unveiled his ambitious master plan for a "city within a city" located on the property of the Twentieth Century-Fox Film Corporation ten miles west of downtown, challenging the latter's viability as the city's center. Shulman was hired to document each newly constructed building as Becket's grand vision came to fruition, and Century City became one of the most photographed locations in Shulman's vast portfolio (plates 25–28). His promotional images of the development's emerging high-rises, modern office interiors, and bustling pedestrian mall helped to make Century City a premier commercial and residential center in the region.

Wilshire Boulevard was conceived as the city's linear business district and became the central artery of its automobile-centric urban plan. When the Shulman family settled in Los Angeles in 1920, Wilshire Boulevard offered a study in contrasts: a drive from west to east took motorists from an unassuming farm road to a broad avenue lined with the mansions and elegant apartments of Hollywood's elite. Today the thoroughfare stretches sixteen miles from downtown to the Pacific Ocean, carrying traffic through some of the busiest intersections—and most ethnically diverse neighborhoods—in the United States. Its architecturally varied edifices dedicated to commerce, religion, entertainment, and culture, such as the Bullocks Wilshire department store (plate 19) and the Los Angeles

County Museum of Art (plate 21), brought prestige to the fledgling metropolis and punctuated the horizon line to the coast.

As his diverse portraits of L.A.'s urban landscapes reveal, Shulman was a populist who embraced a wide range of architectural styles. The region's ideal weather, creative Hollywood culture, radical art movements, and lenient building codes encouraged the type of experimentation that led to inspired and unusual results. Many architectural eccentricities, such as the Watts Towers (plates 31, 32) and the Getty Villa (plate 36), considered kitsch or controversial when Shulman photographed them, are now heralded as international landmarks.

Through intuitive timing, distinctive camera angles, and meticulously choreographed scenery, Shulman created celebrated photographs of residential architecture. His use of models, dynamic perspectives, and creative props such as potted plants and tree branches mounted on tripods (plates 45, 46) allowed him to dramatize all well-designed residential styles, regardless of aesthetics, scale, or the occupants' taste in furniture. As a result of his compositional artistry, carefully sequenced lighting exposures, and the inspired addition of two women in white, Shulman's iconic image of Pierre Koenig's Case Study House #22 (plate 52) captures the efficiency of the architect's design and embodies the optimistic spirit of postwar America. This famous scene helped to establish an international perception of a glamorous Southern California lifestyle. Shulman proudly claimed that this masterpiece was the most published photograph in architectural history.

Shulman's instinctive understanding of Southern California's sunlight and his nuanced darkroom manipulations produced elegantly enhanced residential portraits. He accentuates the dramatic suspension of John Lautner's "Chemosphere," for example, by delineating the structure with a glowing swath of light layered above the sweeping shadow of an overhead cloud (plate 55). Through Shulman's lens, R. M. Schindler's Mackey Apartments (plate 57) and Richard Neutra's Chuey House (plate 58) are transformed into bold monuments of modernity.

Decades after their creation, Shulman's photographs of Los Angeles have evolved beyond images for commercial promotion into critical visual records of the metropolis's evolution. Shulman, who died in 2009 after more than seventy years in photography, was dedicated to the development of his craft, the promotion of his product, and the protection of his legacy. His entrepreneurial vision and the impeccable organization of his seven-thousand-project archive enabled him to share his work with generations of clients in architecture, construction, academia, publishing, and the media. The Getty Research

Institute's stewardship since 2005 of Shulman's vast collection ensures that his images will continue to inform and influence society's comprehension of the built environment.

ACKNOWLEDGMENTS

This book is dedicated to my family and friends for their unwavering support and guidance. I would like to thank Thomas W. Gaehtgens, director of the Getty Research Institute; Andrew Perchuk, GRI deputy director; Wim de Wit, head of the GRI Department of Architecture and Contemporary Art; and Ron Hartwig, vice president of Getty Communications and Corporate Relations, for encouraging my exploration of Julius Shulman's vibrant legacy. I am very grateful for my colleagues' extraordinary contributions to the international exhibition and publication of *Julius Shulman's Los Angeles*, including those at the Getty Research Institute: Susan Allen, Jobe Benjamin, Anne Blecksmith, Lora Chin Derrien, Annette Doss, Beverly Faison, David Farneth, Gail Feigenbaum, Tobi Kaplan, John Kiffe, Irene Lotspeich-Phillips, Marlyn Musicant, Christine Nguyen, Marcia Reed, Mary Reinsch-Sackett, Barry Russakis, Rani Singh, Lena Watanabe, Kevin Young, and Katja Zelljadt; at Getty Communications: Beth Brett, Mary Flores, John Giurini, Julie Jaskol, Maureen McGlynn, Mara Naiditch, Jessica Robinson, Kimberly Sadler, Maria Vélez, and Rebecca Taylor; and at Getty Publications: Greg Britton, former publisher; Rob Flynn, editor in chief; and the publications team of Dinah Berland, senior editor; Catherine Lorenz, senior designer; Amita Molloy, senior production coordinator; and Sheila Berg, freelance manuscript editor.

Christopher James Alexander
Assistant Curator of Architecture and Design
The Getty Research Institute

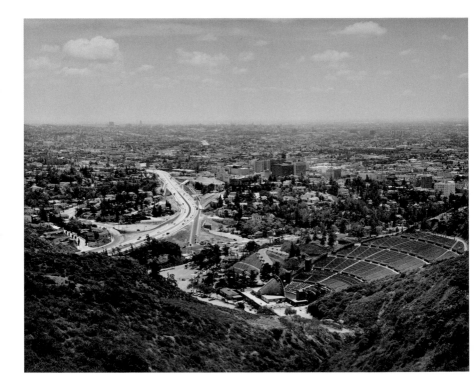

PLATE 3 | VIEW OF THE HOLLYWOOD BOWL WITH DOWNTOWN IN THE DISTANCE, 1954

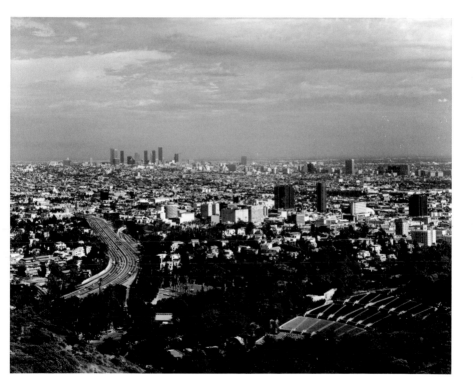

PLATE 4 | VIEW OF THE HOLLYWOOD BOWL WITH DOWNTOWN IN THE DISTANCE, 1986

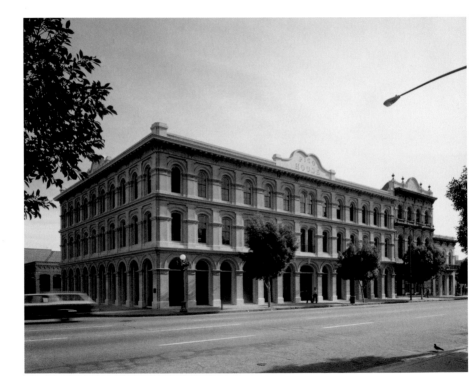

PLATE 5 | PICO HOUSE HOTEL, 1981. EZRA F. KYSOR, ARCHITECT, 1870

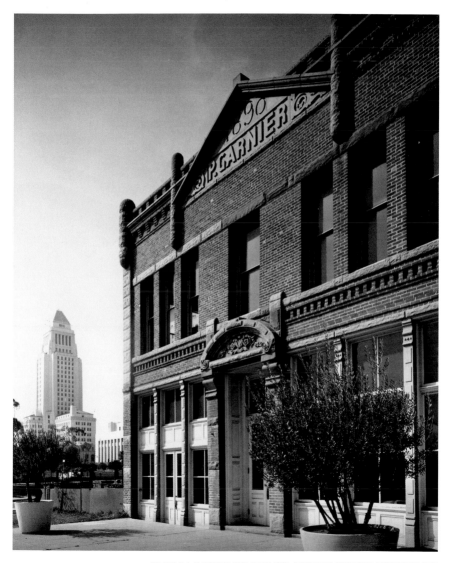

PLATE 6 | GARNIER BUILDING, 1981. ABRAHAM EDELMAN, ARCHITECT, 1890

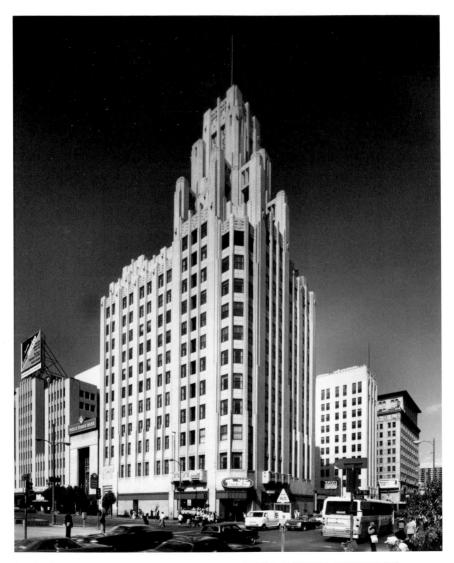

PLATE 7 | TITLE GUARANTEE BUILDING, 1980. JOHN AND DONALD B. PARKINSON, ARCHITECTS, 1931

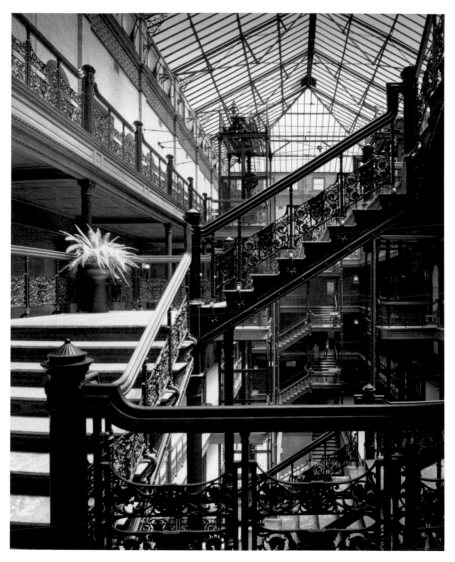

PLATE 8 | BRADBURY BUILDING, 1969. GEORGE H. WYMAN, ARCHITECT, 1893

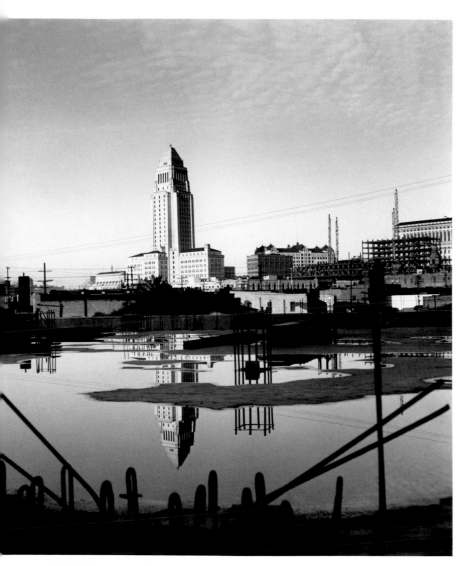

PLATE 9 | VIEW OF LOS ANGELES CITY HALL FROM THE UNION STATION CONSTRUCTION SITE, CA. 1934
JOHN C. AUSTIN, JOHN AND DONALD PARKINSON, AND A. C. MARTIN, ARCHITECTS, 1928

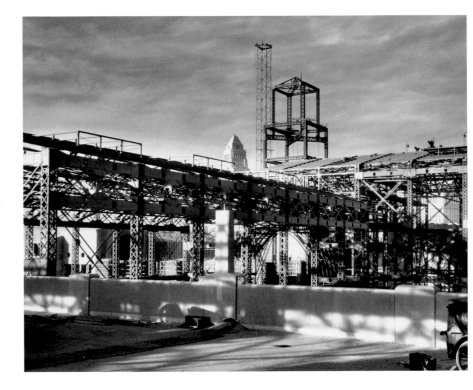

PLATE 10 | UNION STATION UNDER CONSTRUCTION, CA. 1937
JOHN AND DONALD B. PARKINSON, ARCHITECTS, 1934–39

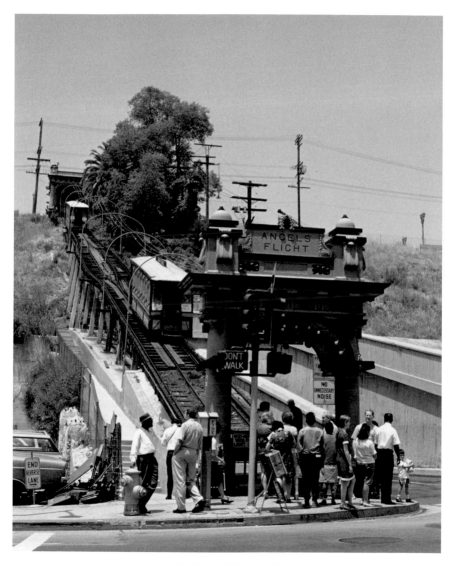

PLATE 11 | ANGELS FLIGHT, 1969. COLONEL J. W. EDDY, ENGINEER, 1901

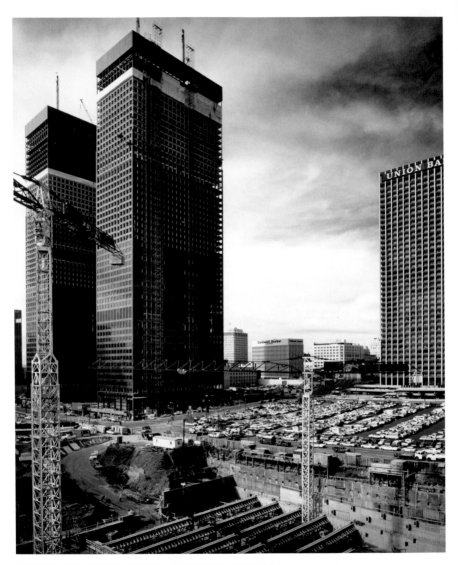

PLATE 12 | ATLANTIC RICHFIELD PLAZA UNDER CONSTRUCTION, 1971
A. C. MARTIN AND ASSOCIATES, ARCHITECT, 1972

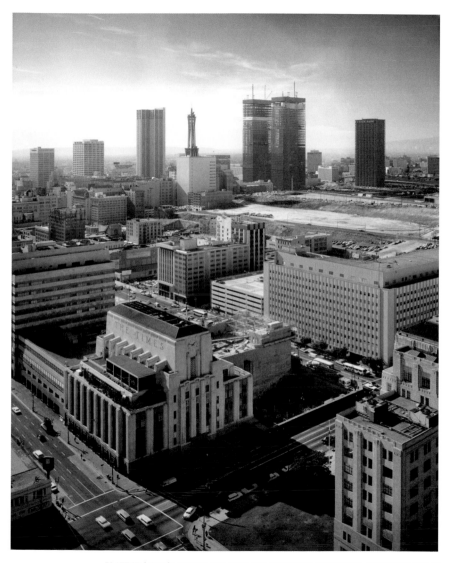

PLATE 13 | TIMES-MIRROR BUILDING, 1971. GORDON B. KAUFMANN, ARCHITECT, 1931–35

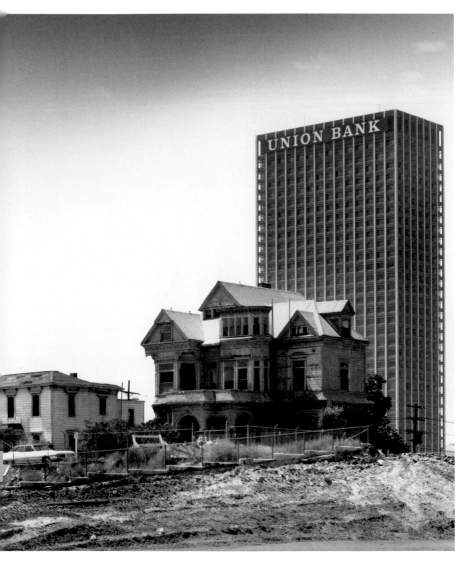

PLATE 14 | "THE SALTBOX" AND "THE CASTLE" (FOREGROUND); UNION BANK PLAZA (BACKGROUND), 1967
ARCHITECTS UNKNOWN, CA. 1890; A. C. MARTIN AND ASSOCIATES, ARCHITECT, 1968

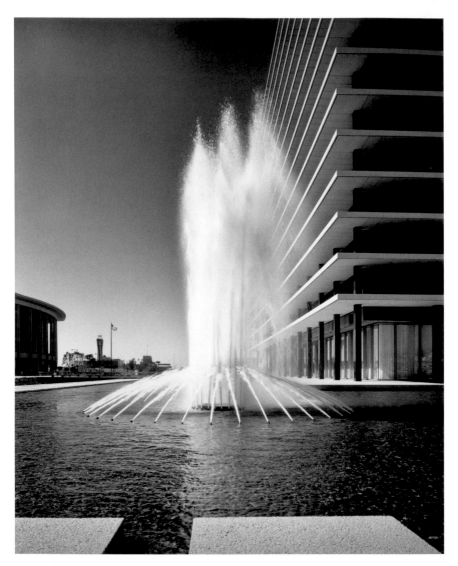

PLATE 15 | DEPARTMENT OF WATER AND POWER BUILDING, 1965
A. C. MARTIN AND ASSOCIATES, ARCHITECT, 1964

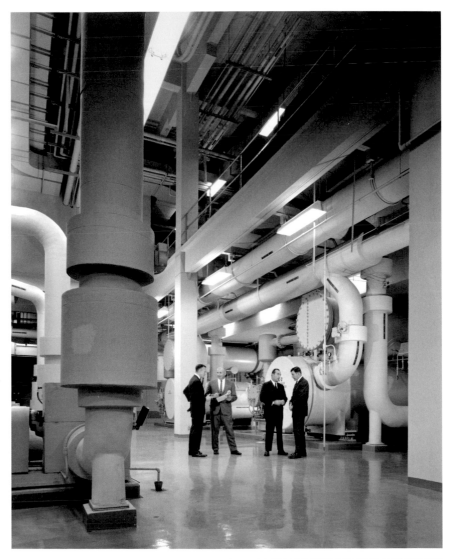

PLATE 16 | DEPARTMENT OF WATER AND POWER BUILDING, 1965
A. C. MARTIN AND ASSOCIATES, ARCHITECT, 1964

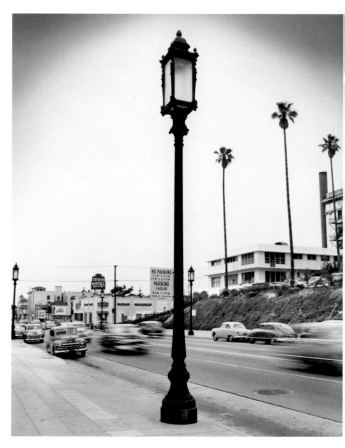

PLATE 17 | WILSHIRE BOULEVARD LAMP POST, 1950

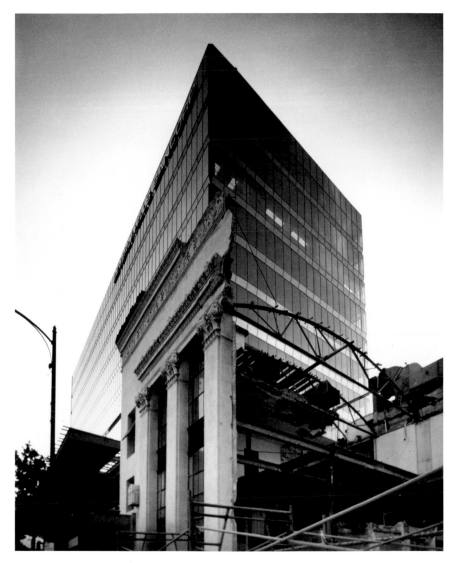

PLATE 18 | BEVERLY HILLS BANCORP BUILDING, 1973. SIDNEY EISENSHTAT, ARCHITECT, 1973

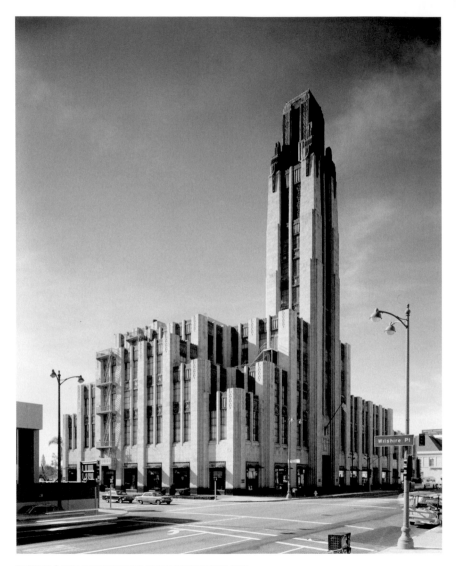

PLATE 19 | BULLOCKS WILSHIRE DEPARTMENT STORE, 1969
JOHN AND DONALD B. PARKINSON, ARCHITECTS, 1928

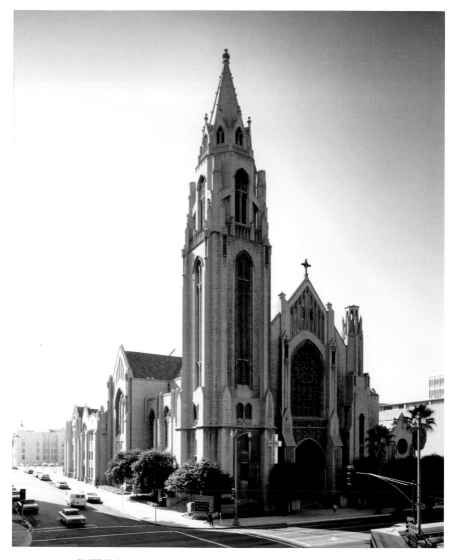

PLATE 20 | IMMANUEL PRESBYTERIAN CHURCH, 1969. CHAUNCEY F. SKILLING, ARCHITECT, 1929

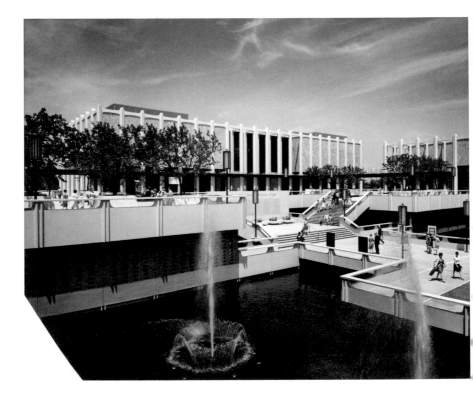

PLATE 21 | LOS ANGELES COUNTY MUSEUM OF ART, 1965. WILLIAM PEREIRA AND ASSOCIATES, ARCHITECT, 1965

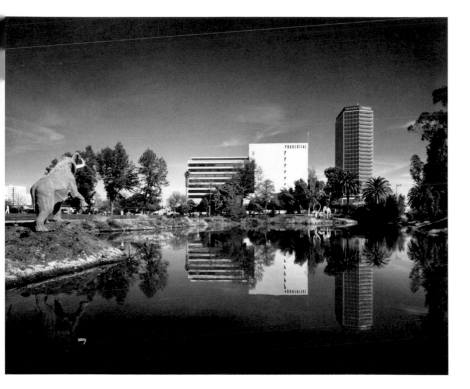

PLATE 22 | LA BREA TAR PITS, 1964

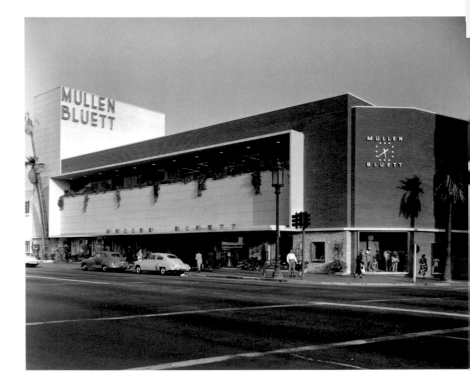

PLATE 23 | MULLEN & BLUETT DEPARTMENT STORE, 1949
STILES O. CLEMENTS OR ROBERT CLEMENTS SR., ARCHITECT, 1949

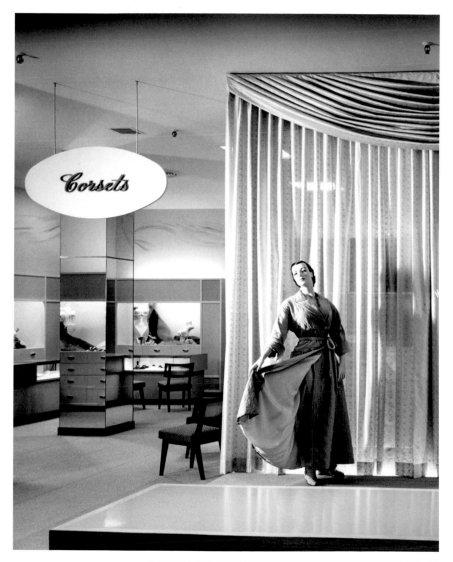

PLATE 24 | J. W. ROBINSON'S BEVERLY DEPARTMENT STORE INTERIOR, 1951
WILLIAM L. PEREIRA, CHARLES LUCKMAN, AND RAYMOND LOEWY, ARCHITECTS, 1951

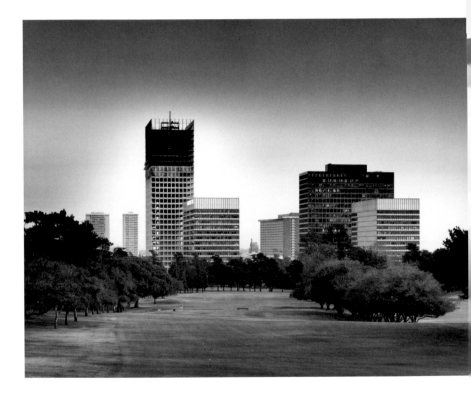

PLATE 25 | VIEW OF CENTURY CITY FROM THE LOS ANGELES COUNTRY CLUB GOLF COURSE, 1968

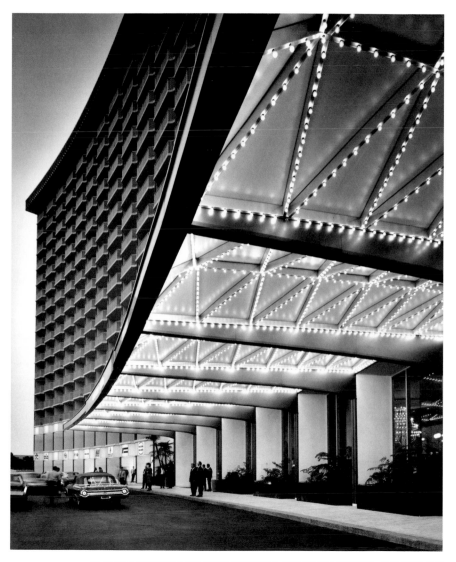

PLATE 26 │ CENTURY PLAZA HOTEL ENTRANCE, 1966. MINORU YAMASAKI, ARCHITECT, 1966

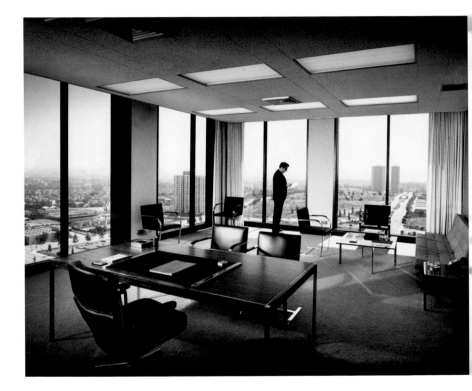

PLATE 27 | 1901 AVENUE OF THE STARS OFFICE INTERIOR, 1968. HELLMUTH, OBATA & KASSABAUM, ARCHITECT, 1968

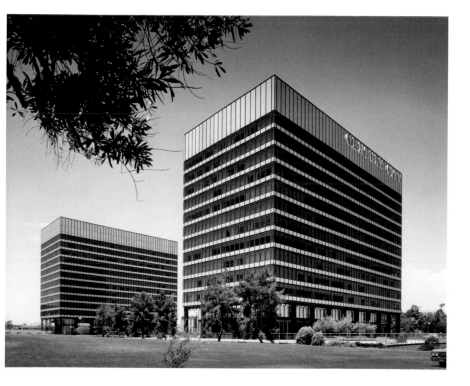

PLATE 28 | CENTURY CITY GATEWAY TOWERS, 1966. WELTON BECKET AND ASSOCIATES, ARCHITECT, 1963-64

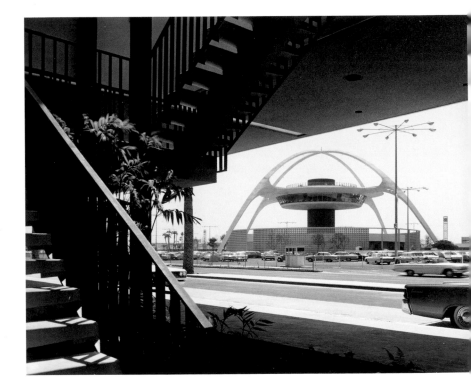

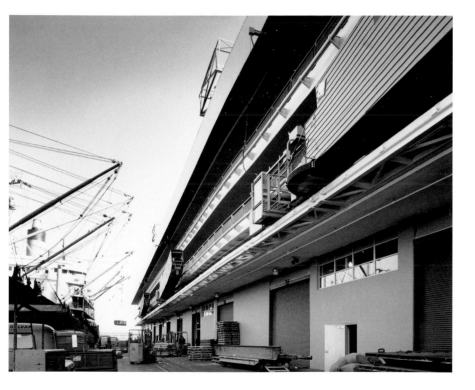

PLATE 30 | L.A. HARBOR DEPARTMENT, FACILITIES AND TERMINAL BUILDING, 1963
KISTNER, WRIGHT AND WRIGHT, ARCHITECT, CA. 1960

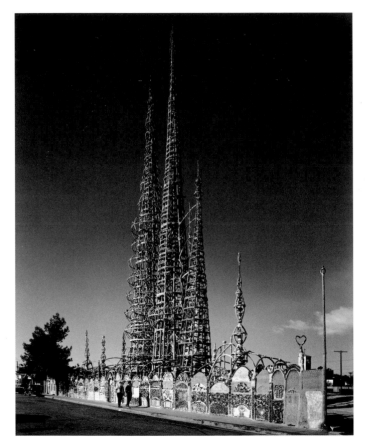

PLATE 31 | WATTS TOWERS, 1967. SIMON RODIA, ARTIST, 1921–55

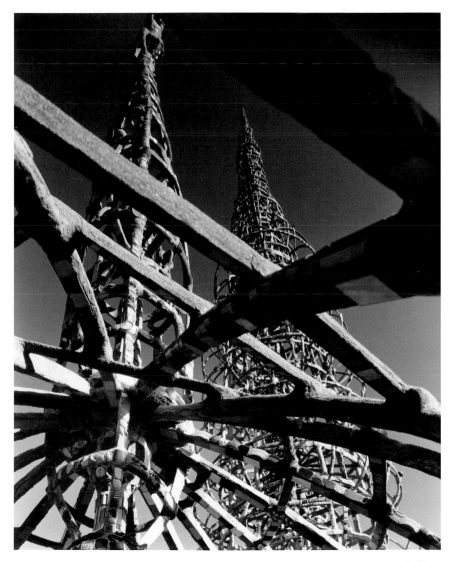

PLATE 32 | WATTS TOWERS, 1967. SIMON RODIA, ARTIST, 1921–55

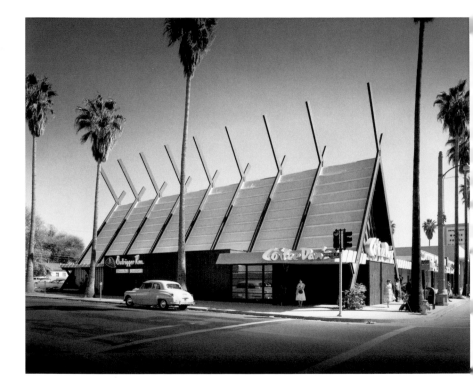

PLATE 33 | COFFEE DAN'S COFFEE SHOP, 1958. PALMER AND KRISEL, ARCHITECT, 1956

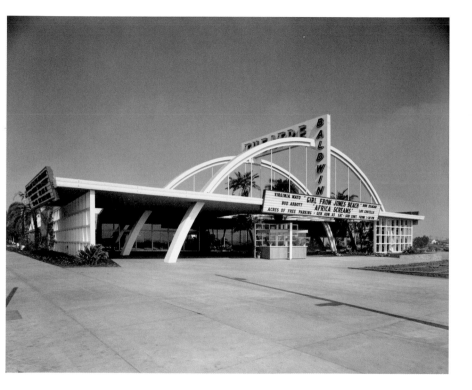

PLATE 34 | BALDWIN THEATER, 1949. LEWIS EUGENE WILSON, ARCHITECT, 1949

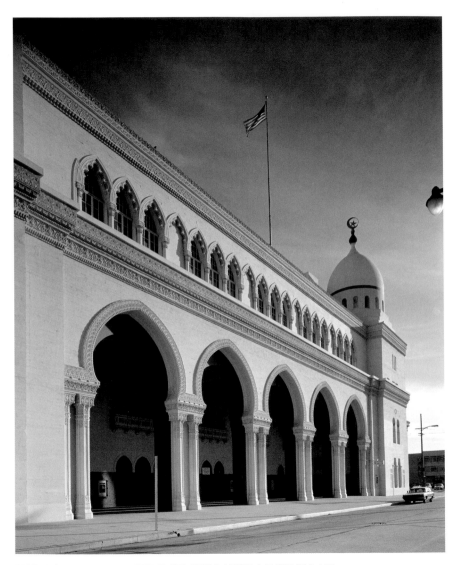

PLATE 35 | SHRINE CIVIC AUDITORIUM, 1975. JOHN C. AUSTIN, A. M. EDELMAN, AND
G. ALBERT LANSBURGH, ARCHITECTS, 1926

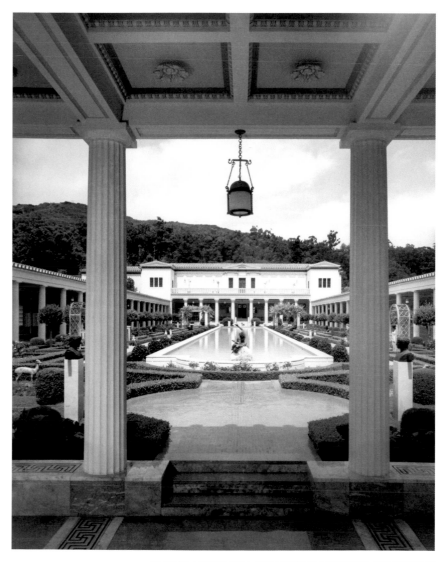

PLATE 36 | GETTY VILLA, 1979. LANGDON AND WILSON, ARCHITECT, 1974

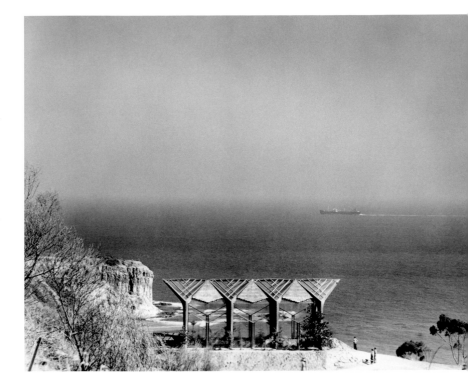

PLATE 37 | WAYFARERS CHAPEL, 1951. LLOYD WRIGHT, ARCHITECT, 1949

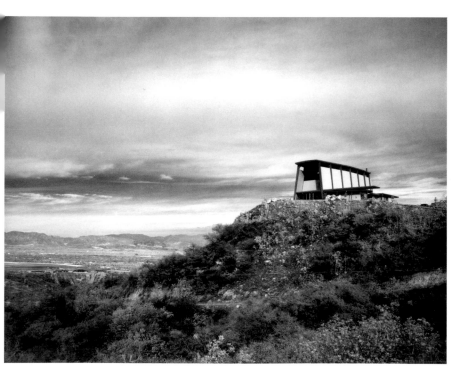

PLATE 38 | BEL AIR PRESBYTERIAN CHURCH, 1961. HAL C. WHITTEMORE, ARCHITECT, 1960

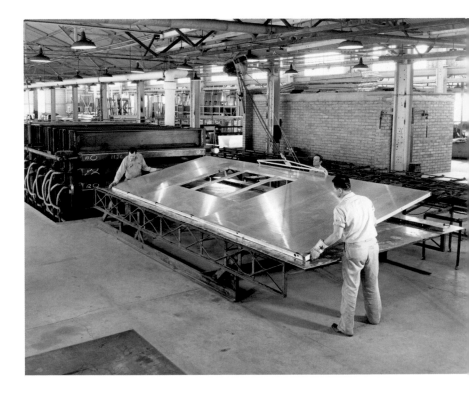

PLATE 39 | SOUTHERN CALIFORNIA HOMES, INC., FACTORY, 1947

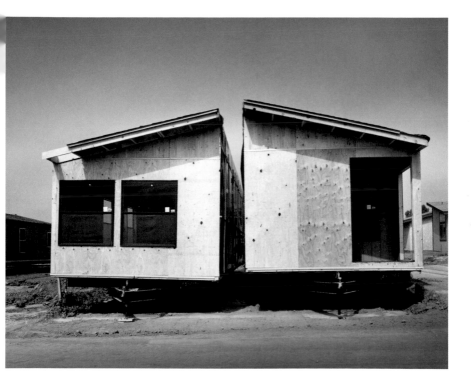

PLATE 40 | RANCHO VENTURA HOME UNDER CONSTRUCTION, 1981. KERMIT DORIUS, ARCHITECT, 1981

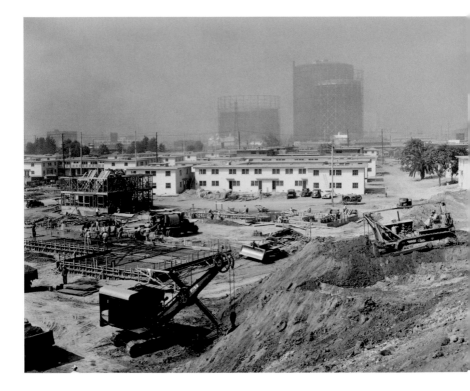

PLATE 41 | ALISO VILLAGE, 1942. LLOYD WRIGHT, GEORGE G. ADAMS, WALTER S. DAVIS, RALPH C. FLEWELLING,
EUGENE WESTON JR., AND LEWIS E. WESTON, ARCHITECTS, 1941–53

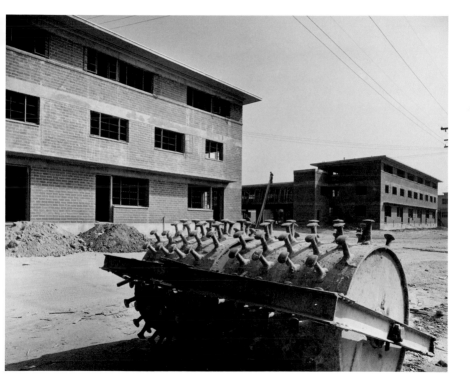

PLATE 42 | ALISO VILLAGE, 1942. LLOYD WRIGHT, GEORGE G. ADAMS, WALTER S. DAVIS, RALPH C. FLEWELLING, EUGENE WESTON JR., AND LEWIS E. WESTON, ARCHITECTS, 1941–53

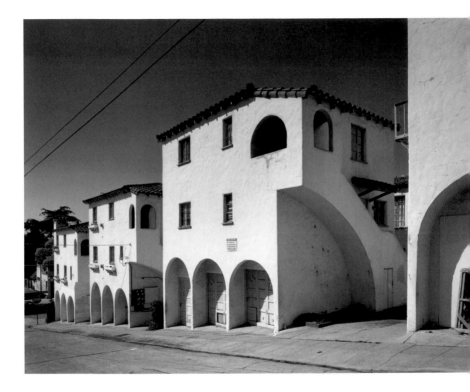

PLATE 43 | ECHO PARK AVENUE RESIDENCES, 1978. ARCHITECT UNKNOWN, DATE UNKNOWN

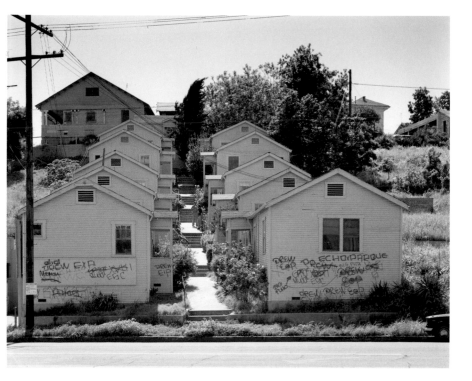

PLATE 44 | BUNGALOW COURT ON SUNSET BOULEVARD, 1978. ARCHITECT UNKNOWN, DATE UNKNOWN

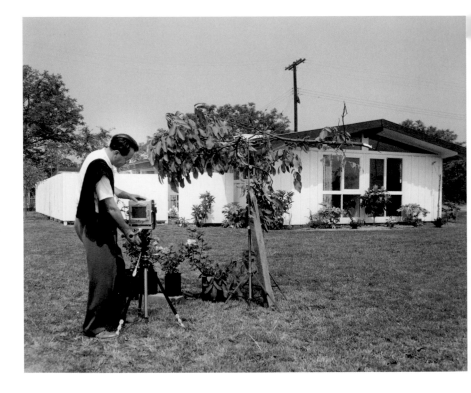

PLATE 45 | SHULMAN STAGING A PHOTOGRAPH OF A MAY HOUSE, 1954. CLIFF MAY, ARCHITECT, CA. 1954

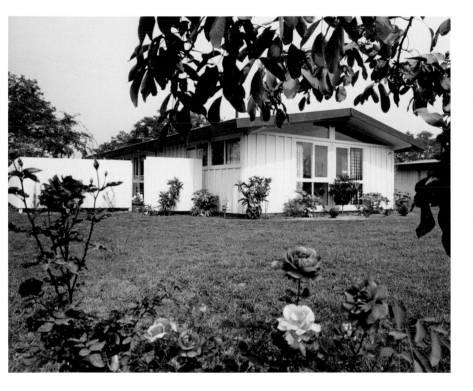

PLATE 46 | PHOTOGRAPH AFTER SHULMAN'S STAGED COMPOSITION OF A MAY HOUSE, 1954
CLIFF MAY, ARCHITECT, CA. 1954

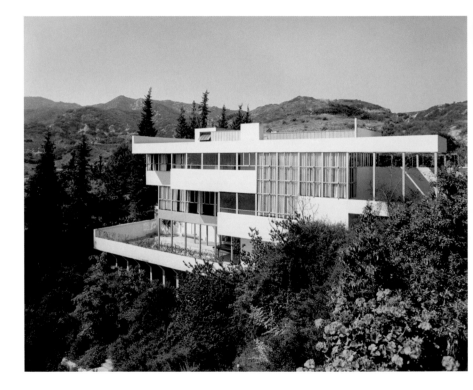

PLATE 47 | LOVELL "HEALTH" HOUSE, 1950. RICHARD NEUTRA, ARCHITECT, 1929

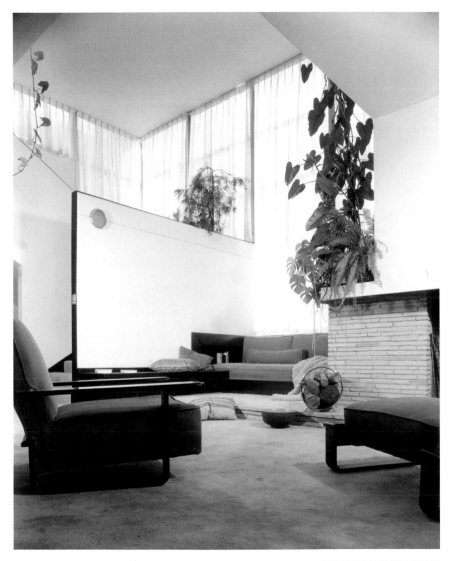

PLATE 48 | LOVELL "HEALTH" HOUSE INTERIOR, 1950. RICHARD NEUTRA, ARCHITECT, 1929

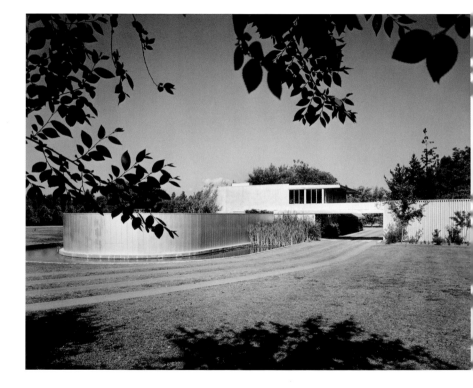

PLATE 49 | VON STERNBERG RESIDENCE, 1947. RICHARD NEUTRA, ARCHITECT, 1936

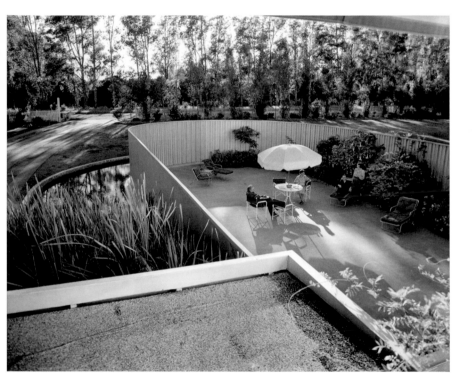

PLATE 50 | VON STERNBERG RESIDENCE, 1947. RICHARD NEUTRA, ARCHITECT, 1936

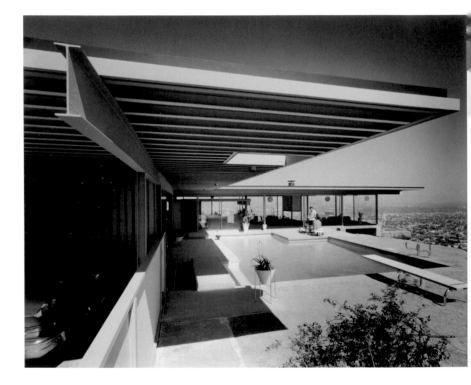

PLATE 51 | CASE STUDY HOUSE #22, 1960. PIERRE KOENIG, ARCHITECT, 1960

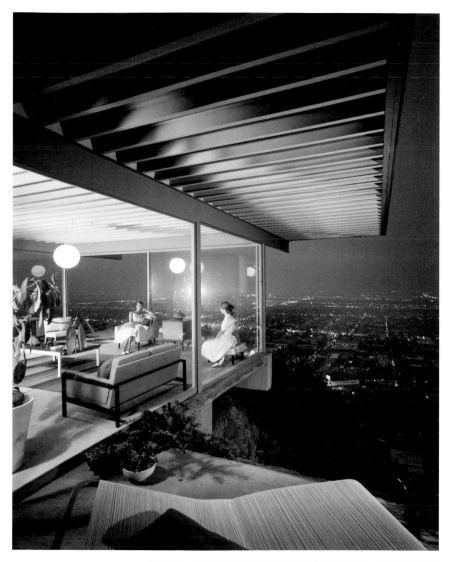

PLATE 52 | CASE STUDY HOUSE #22, 1960. PIERRE KOENIG, ARCHITECT, 1960

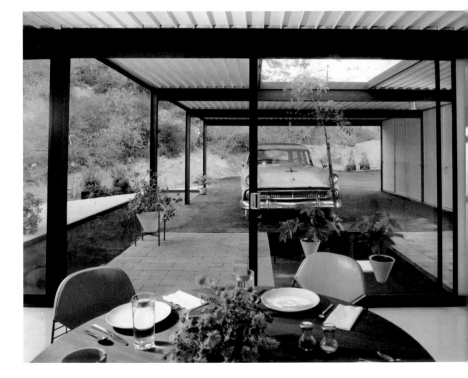

PLATE 53 | CASE STUDY HOUSE #21, 1958. PIERRE KOENIG, ARCHITECT, 1958

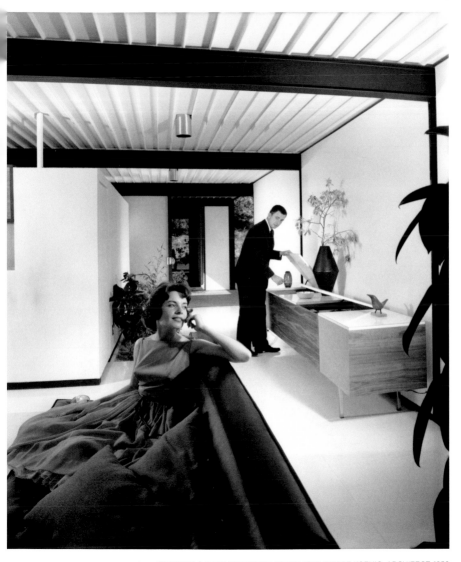

PLATE 54 | CASE STUDY HOUSE #21, 1958. PIERRE KOENIG, ARCHITECT, 1958

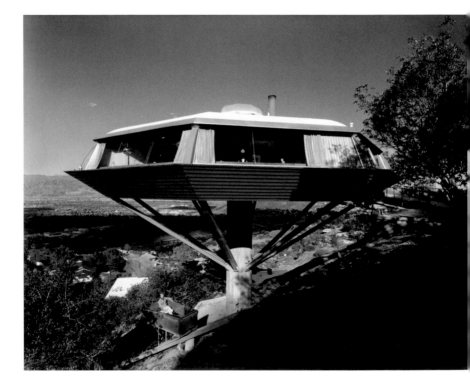

PLATE 55 | MALIN RESIDENCE, "CHEMOSPHERE," 1960. JOHN LAUTNER, ARCHITECT, 1960

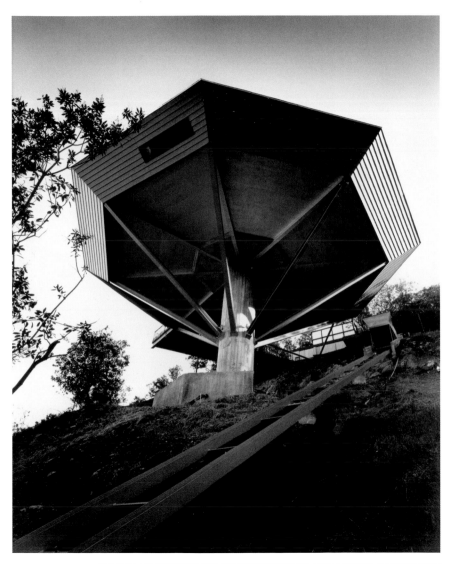

PLATE 56 | MALIN RESIDENCE, "CHEMOSPHERE," 1960. JOHN LAUTNER, ARCHITECT, 1960

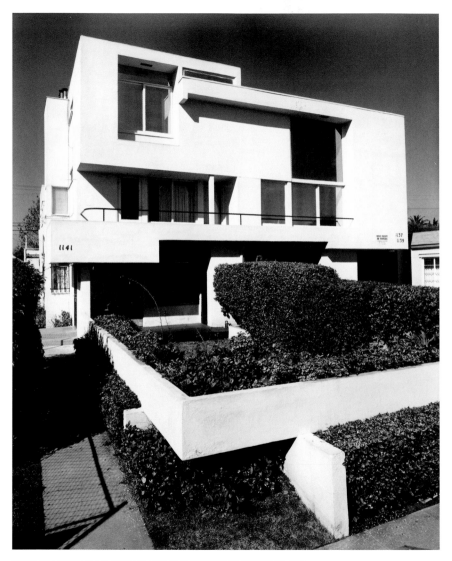

PLATE 57 | MACKEY APARTMENTS, 1939. R. M. SCHINDLER, ARCHITECT, 1939

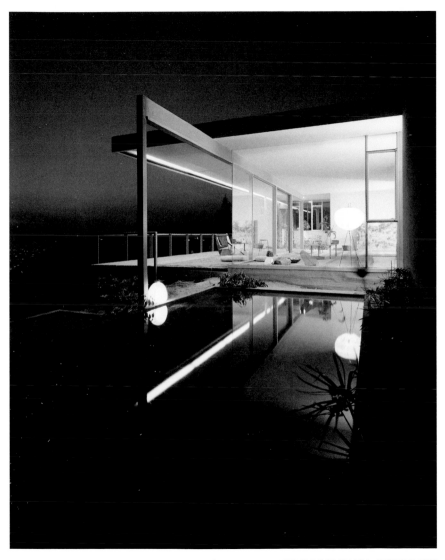

PLATE 58 | CHUEY HOUSE, 1956. RICHARD NEUTRA, ARCHITECT, 1956

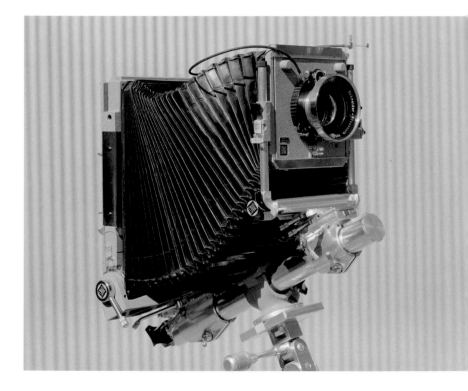

PLATE 59 | SINAR 8 × 10 CAMERA, 1962

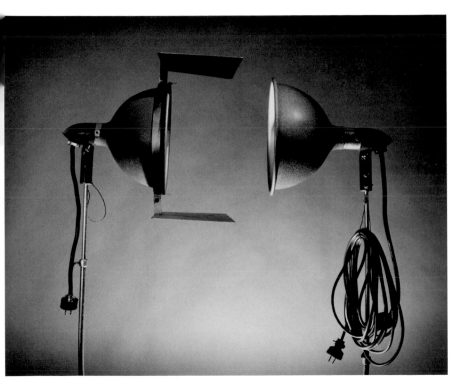

PLATE 60 | PHOTO LAMPS, 1976

A NOTE ON THE PLATES

All reproductions in this book are from photographs by Julius Shulman and are © J. Paul Getty Trust, Julius Shulman Photography Archive, Getty Research Institute, Los Angeles, 2004.R.10. Titles are conventionally used designations for Shulman's architectural views, descriptive of the building or vista and not assigned by the photographer. All photographs are gelatin silver prints.